THE CAPITOL IN ALBANY

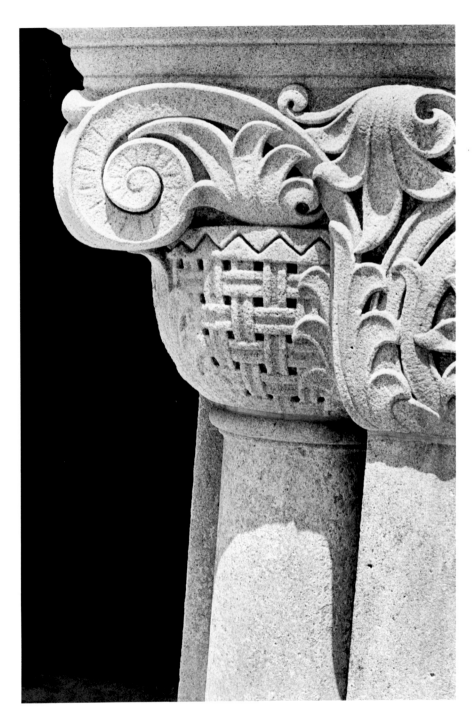

Judith Turner, *Capital, South Side Porte Cochere Gallery, Eastern Approach*

THE CAPITOL IN ALBANY

PHOTOGRAPHS BY

WILLIAM CLIFT
STEPHEN SHORE
JUDITH TURNER
DAN WEAKS

PREFACE BY

MARIO M. CUOMO
WARREN M. ANDERSON
STANLEY FINK

ESSAY BY

WILLIAM KENNEDY

AN APERTURE BOOK

IN ASSOCIATION WITH THE TEMPORARY STATE
COMMISSION ON THE RESTORATION OF THE CAPITOL

The Temporary State Commission on the Restoration of the Capitol was created in 1979 to develop a long-term plan for the restoration and rehabilitation of the New York State Capitol, a National Historic Landmark. In 1982 it published *The Master Plan for the New York State Capitol.* Subsequently, the Commission has directed its efforts toward the implementation of the Master Plan and the interpretation of the Capitol and its rich heritage.

Temporary State Commission on the Restoration of the Capitol, Alfred E. Smith State Office Building, PO Box 7016, Albany, New York 12225. 518-473-0341.

PREFACE

THE NEW YORK STATE CAPITOL is a building of great architectural and historical significance, a fact recognized in 1979 when it was designated a National Historical Landmark. It is one of the preeminent examples of American public architecture of the late nineteenth century. It is a place where, for more than a century, dedicated, creative, and knowledgeable men and women have successfully devised solutions to the problems facing New Yorkers. It is a building alive with both the memories of the people who worked here and the fruits of their labors. In a larger sense, it is the symbol of the principles and process of our form of government.

For each of us, the Capitol is also a very special and personal place. There are rooms, corners, and doorways here, unremarkable to the casual visitor but full of meaning to us because of their links to our own careers of governmental service. We are surrounded by the Capitol's idiosyncrasies, which over time have taken on a personal significance. How curious that just as the process of making public policy never ends, so the carving of stone throughout the building has never been completed.

Yet those of us who work in the New York State Capitol sometimes forget to look at the building. The challenges we face often distract us from the surroundings in which we labor. The comments of impressed visitors, however, and the enthusiastic chatter of young school children whom we pass on our way to meetings always remind us of just how remarkable our workplace is.

We are excited to be able to augment our personal visions of this great building with those of the four photographers whose work makes up this book. William Clift, Stephen Shore, Judith Turner, and Dan Weaks each viewed the Capitol in a unique way. Each has captured a particular effect of light, a specific juxtaposition of forms, or a certain perspective—an achievement that has eluded those of us who lack their visual gifts. Bill Kennedy has complemented their work with his words. More importantly, they all have shared their visions with us and thereby enriched our appreciation of the Capitol. Just as today's events shape the meaning of this building for us, so the images of this book will influence the way we look at it in the future.

THE HONORABLE MARIO M. CUOMO, Governor, State of New York

THE HONORABLE WARREN M. ANDERSON, Majority Leader, New York State Senate

THE HONORABLE STANLEY FINK, Speaker, New York State Assembly

THE CAPITOL: A QUEST FOR GRACE AND GLORY

WILLIAM KENNEDY

W E WERE SITTING ON THE STEPS that lead down into Capitol Park west, making notes on the hundreds of people who had been here during the lunch hour on this perfect summer day of 1985. The great office buildings on Capitol Hill, Albany's acropolis, had disgorged their hungry, sun-seeking denizens, who quickly opened their lunch bags or lined up at the score of sidewalk pushcarts to buy fruit, and egg rolls, and hot dogs, and they lolled on these steps and on the park's sweet greensward until time and the egg rolls ran out. Then they went away.

Now the day was making long shadows, and all that remained of the lunchers was a bit of their spoor: grease spots on the steps. Three young boys rode up on bikes, and two of them rolled their trousers and waded into the park's small pool, where minigeysers rise and fall in season. The boys were questing for coins that profligate dreamers sometimes toss into the water along with their secret wishes. The third boy approached the steps and asked if the man taking notes was a reporter.

"Sort of," he was told.

"You look like one. What you writin' about, the buildings?"

"About this big one, the Capitol. It's very famous and very old."

"Is it?"

"Yep. They started to build it 122 years ago."

"Wow!" said the boy. "That's almost a century."

Excess beyond comprehension: precisely.

The Capitol is, in all respects, a presence beyond human scale. Inside it or outside it, the eye is gluttonous, the brain festive, the imagination overtaxed. It is the architectural snowball that became an avalanche, exceeding all expectations except those of the men who first conceived it, who wanted the symbols of America to inhere in it; and so they do. What also inheres is the monumentalism of one of the last load-bearing masonry buildings in America and a sprawl of superlatives that have become its historical baggage.

There is, for instance, the cost of building it. Governor Lucius Robinson (1877–79), a frugal man, called it "a public calamity . . . without parallel for extravagance and folly." By 1899, after it had been abuilding for thirty-six years, the legislature refused to spend any more money finishing it and declared it complete. Cost to that point: $25 million, the most ever expended on a building in North America. But it was hardly complete, and the new governor in 1899, Theodore Roosevelt, immediately undertook alterations that by 1902 proved to be not only unsatisfactory but dangerous. Alterations are still going on today, as is the effort to finish it.

It will never be finished; is, indeed, unfinishable. But it demands eternal attention,

deserves completion or restoration of certain splendid parts, and calls out indignantly for elimination of the abuses that have been perpetrated through the years on its glorious corpus. If all the words written in, about, and because of the existence of this corpus were suddenly turned into raindrops, the entire population of the world would be awash in a deluge of vowels and consonants. This book adds a few drops to that deluge, with reverence and beauty: the reverence in these words, the beauty in the photographs that follow them.

The American Architect and Building News in 1881 called the Capitol "one of the greatest buildings of the century." An early critic said of the Senate Chamber (the work of the eminent architect H. H. Richardson and one of his upcoming associates, Stanford White) that it was "the most beautiful room in the United States." Another critic wrote that the Chamber "surpasses in magnificence any legislative hall on this continent."

The Assembly Chamber, the madly bold design of Leopold Eidlitz, a major architect and theorist to his contemporaries, was described by a critic in Scribner's Monthly in 1879 as "the most monumental and most honorable work of public architecture this country has to show for itself." But it proved to be structurally unsound, stones fell onto the desks of fearful legislators, and after only nine years the great ceilings with their groined arches were reconstructed and lowered, their grandeur diminished.

Richardson's Great Western Staircase in the Capitol, also called the Million Dollar Staircase (it cost more than a million), has been described by a present-day architectural historian as "possibly the most intricate one in the western world." Also, the feud over styles of design among the Capitol's architects (Thomas Fuller was the first, replaced by the triadic team of Richardson, Eidlitz, and Frederick Law Olmsted, they in turn replaced by Isaac Perry) was viewed, in its day, as "a controversy in architectural politics unprecedented in our history."

This sort of maximizing can go on, has gone on, and is well documented. But let us consider certain new and current elements of the Capitol's history and turn our attention to a series of views of the building's four exterior sides, the likes of which only birds have heretofore seen.

These photos were made by Dan Weaks, who works with a truck that is outfitted to raise his camera to a height well above normal eye level. We seem to be looking at the Capitol's eastern facade, for instance, from the perspective of a helicopter hovering over State and Eagle Streets, our eye at the building's dead center in the imaginary cross hairs of a telescope. Weaks takes multiple photos of his subject, then pieces them together like a jigsaw puzzle to create his pictures-that-never-were. The human scale is always there, those tiny, ambulating blurs in all his foregrounds; and while they are most aptly in scale against the great facades, they are also the presences without which there would be no such epic scope to photograph.

Stephen Shore's color photographs of the Capitol's exterior give us a perspective of another sort: a sidewalk realism, but with natural light that is constantly recoloring the great building. Now it is a wan beige in the summer sun, now a bone gray, or a rich, shadowed tan, or a bright, sunlit white with greenish shadow, or a stark bluish-gray on a day when the

matching gray trees have shed all their leaves, and yet the grass is still as green as when summer was here.

Shore finds his blue skies reflected equally blue in the Capitol windows, and also in the windbreaker of a woman on a park bench. He finds the lion guarding the porte-cochere entrance beneath the eastern steps to be not one lion but three: twice reflected in the glass and the polish of a parked Le Baron. He will discover an upward angle that proves the Capitol's facade is predominantly the work of stone carvers, from another angle that it is all Romanesque arches, and from yet another a nonesuch grid of parallel and perpendicular lines. A long look at the Shore photos is repaid by revelation. In one foliated corbel he finds a handsome hound with his tongue out. He has, perhaps, discovered a stone carver's pet, but he has also discovered that the hound's cranial fracture and bisected left ear are part of a line of mortar that has repaired, with great finesse, serious damage to the corbel caused by weather, or vandals.

The abundance of such carvings, the extraordinary stonecutting, all done with tools passed on from medieval time, both crafts all but vanished from the world in this age of steel and poured concrete, give anyone randomly touring the Capitol's interior a passport to a lost age, an age of belief in which a symbol carried ancestral weight: a log cabin in the wilderness, a broken chain beneath an emancipated slave.

On the first floor by the Senate staircase a tour guide was instructing visitors about the carvings that adorn the balustrade. Darwin's theory of evolution was new when the staircase was being built, said the guide, and the designers decided to begin at the bottom with the symbolic carving of a single cell, and then rise, with the ever-increasing complexity of living things, to the fourth floor, when the final carving would depict man at the summit of living ascendancy.

But many of the carvers were Catholics who would have none of such heathen jabber, and they refused to carve man at the top. So evolution, said the guide, now ends with the elephant.

We followed the carvings upward and near the fourth floor found the rhino, the hippo, the mammoth, and a penultimate elephant; but we interpret the last carved panel not as an ultimate elephant but as a recumbent camel. I think the carvers were having their way with life, just as they did with death in a carving on the Million Dollar Staircase showing an antlered stag with a huge arrow in its back. The carving is captioned "Non Effugit."

The photos of Judith Turner provide another vision of Capitol abstractions: the geometry of pillars and pedestals, stairs and shadows. She turns her cubist eye on a precubist world and finds poetry in polished marble, combed sandstone. She is the minimalist any visitor to the Capitol must become or else lose sight of the delicacy of the basket woven into a corbel by a carver, or the backlighting that silhouettes an archway, or a tumultuous rush of lines and angles that overpower a corner until one sees the sinuous bobcat in the background, climbing the foliage of an adjacent arch: and vision is arrested, and delighted.

William Clift wants space to be encompassed. In his photos he seeks out a stairwell, a portico, a corner of the Assembly Chamber, the fireplace wall in the Executive Chamber before it was redecorated, the Capitol by night from a distance, the press room on the third floor, a view to the north over three Capitol dormers. He finds beauty not in isolated elements but in the ensemble effect, in the way a given place accumulates furniture, and flags, and a vista, and a perimeter.

His photographs suggest another truth: that the Capitol is a museum not only of stone carving and architecture, but of portrait painting, of political photography, of military artifacts. The Capitol is a rich repository of flags, guns, uniforms, letters, and photos from the Civil War, other wars. In a small cavelike room under the Million Dollar Staircase, you must handle the photos with white gloves: tintypes of women taken off dead soldiers on Southern battlefields, or photos of Union soldiers taken by Mathew Brady's studio, or a letter from a wounded soldier to his lieutenant, asking that his buddies write him and yearning from his hospital bed to rejoin the company.

These things are not entirely accessible to the public but await display in a Civil War room or a military museum yet to be created. Some items are on view in corridors of the Capitol: a Confederate doctor's surgical case alongside his foot artillery sword, blades with two moral edges; and the uniform worn by Colonel Elmer Ephraim Ellsworth, born in Saratoga County, sometime resident of Troy, and the first Union officer to die in the Civil War: shot through the chest by the proprietor of an Alexandria, Virginia, hotel, from whose roof Ellsworth had pulled down the Confederate flag. When President Lincoln heard the news of Ellsworth's death, he wept.

Now move along. There's the courtyard, once planned by architect Fuller as a sculpture garden to educate the public about art, but never completed. Now it is half full of a latter-day copper roof that covers the Capitol's one-story cafeteria, added in 1923. Ventilators, a ladder, the green corrosion of the copper roof, and not much else dominate the dismal, unsightly central core of the great building. There are plans to create an open garden in that courtyard, with fountains and statuary and with access from all sides, and maybe that will happen one day.

We can go upstairs now to the Legislative Correspondents room and see how it's changed in the twenty years since we last used its facilities, and the answer is: Not much. What is new is that it's quiet. You don't hear typewriters, you don't even see them, because they've been replaced by video display terminals. Photos of certain favored governors line the upper walls of the downstairs part of the room: Teddy Roosevelt, Tom Dewey, Al Smith, Big Bill Sulzer, the only governor to be impeached, and Martin H. Glynn, the *Albany Times-Union* editor who was Sulzer's lieutenant governor, and who replaced him.

A young Nelson Rockefeller looks out from the east wall and Dan Barr, who used to report on politics for the *Times-Union* and who later became a Rockefeller press aide, is having coffee with a visitor on The Shelf, the upstairs portion of the press room that juts out

over half the lower room. This is the truly historical section, where the pool and card tables and the beer are kept. And it is where Harry Truman one day played "The Missouri Waltz" on the piano. The boys had a sign made up and sent it to Harry for his signature, and it is there on the piano now. It first read: "Harry Truman Played Here, Oct. 8, 1955." Harry signed it but inserted the words *the piano* after the word *played*, and added in a footnote: "Just to make plain what was played," for like everybody else in politics, Harry knew that a twenty-four-hour poker game was a significant element on The Shelf.

Dan Barr was a young reporter in the mid-1950s when he encountered the poker game. Some of the regulars were Jimmy Desmond and Dick Lee of the *New York Daily News* and Warren Weaver and Doug Dales of the *New York Times*, Emmett O'Brien of Gannett News Service, and Arvis Chalmers of the *Albany Knickerbocker News*. Dan knew you couldn't just sit down and play poker, that you had to be invited. So he watched the game patiently for six months, and then one day Jimmy Desmond looked up and said to him, "Well, kid, you wanna play?"

Dan brought Rockefeller up to the press room one day, his first visit, and the Governor was depressed by the dinginess of it. Said Dan: "Nelson told Emmett O'Brien and other old timers here that he'd renovate the place, extend The Shelf, clean it up, and modernize it." The cadre of the press corps took this offer under advisement, then told the Governor, "No thanks. We want it just the way it is."

That's the way it still is, and it's not bad at all as press rooms go. It looks like a press room, and it feels like a press room, and while there is only a card game maybe once a month nowadays, the stakes are the same as they were in the fifties: a quarter, half a dollar, and a dollar. "Inflation has never hit this place," Dan Barr said.

In William Clift's photo of a downstairs corner of the press room, the face of Mario Cuomo stares out at the viewer. Governor Cuomo, the incumbent at this writing, personally oversaw the refurbishing of the Executive Chamber, the most recent of the Capitol's modern restorations.

Governor Cuomo took us on a tour of the room that, before his tenure, had been called the Red Room, after its red rug and draperies, and was used mainly for press conferences. The sumptuous appointments of the room's designer, architect Richardson, had been long since replaced with mock Colonial furniture and chandeliers; radiators had blocked the full-length windows; the handsome Philippine mahogany walls had been gouged in numerous places to hang paintings; and a mighty clutter of chairs and lights and wiring for cameras and micro-phones had overthrown the room's original purpose: to give dignity and elegance to the office of the chief executive.

Now press conferences are held elsewhere, a replica of the original multicolored floral rug is on the floor, the Colonial revival, the red decor, and the radiators are all gone, and the

walls have been patched, polished, and stripped of paintings. Will the paintings go back up?

"Only if I lose the election," said the Governor, who prefers mahogany to bad portraiture.

The room looks today very like it did when Governor Alonzo B. Cornell entered it for the first time on September 30, 1881: luxurious, tasteful, esthetically pleasing. It is now used for ceremonial occasions, visitors come through on tours, and the Governor paces in it. He does not use the eight-and-a-half by five foot desk that Grover Cleveland and Theodore and Franklin Roosevelt used when they governed the state. "If I sat at it," the Governor said, "the newspapers would say I've got a Benito Mussolini complex." He works in a smaller office, adjacent to the chamber, using a smaller desk that once belonged to F.D.R.

What does the Governor think about such rooms, about the Capitol itself, and what it stands for?

"I love it," he said, and he pointed to the splendid fireplace that, as he explains to visiting schoolchildren, used to be the only source of heat in the chamber.

"Then I take the kids to the window and have them look out at the modern South Mall, so different from all this old way of life here, and I tell them that there were human beings here a hundred years ago, and there'll be human beings here a hundred years from now, and that we're only part of a continuum.

"I feel like a visitor here myself," the Governor went on, "and the more time you spend on history, the more you feel that way. I'm very leery about changing anything or spoiling anything. We have to preserve things for generations that haven't been born yet, and being in this room makes you think that kind of thought."

The great structures of American political history were designed to dominate the communities that gave them power, their domes and towers thrusting upward to the heavens with the message that the law must be exalted. Albany's Capitol was to have a tower, but all designs proved either unwieldy or excessive, and it was never built. Even without it the building has dominated the city, and the state, for a century.

The sleek towers of its new neighbor, the South Mall, more formally known as the Nelson A. Rockefeller Empire State Plaza, now rise higher, but the Capitol is not diminished. It remains a giant among buildings, radiating the complex and multiple meanings of lawmaking, political debate, and the historical record of it all. It looms before us at the top of State Street hill like Franz Kafka's castle, and like that remarkable literary creation, it suggests a quest for grace, not by the individual in this case, but by the community.

Those long years of building the Capitol, the myriad restorations, the eternal tinkering with it, and the indefatigable will to finish the unfinishable, all bespeak a communal need to perfect a work of art: to embody meaning that may be venerated now and forever. The Capitol is, no doubt about it, an imperfect work of art, but it is nevertheless a very great one.

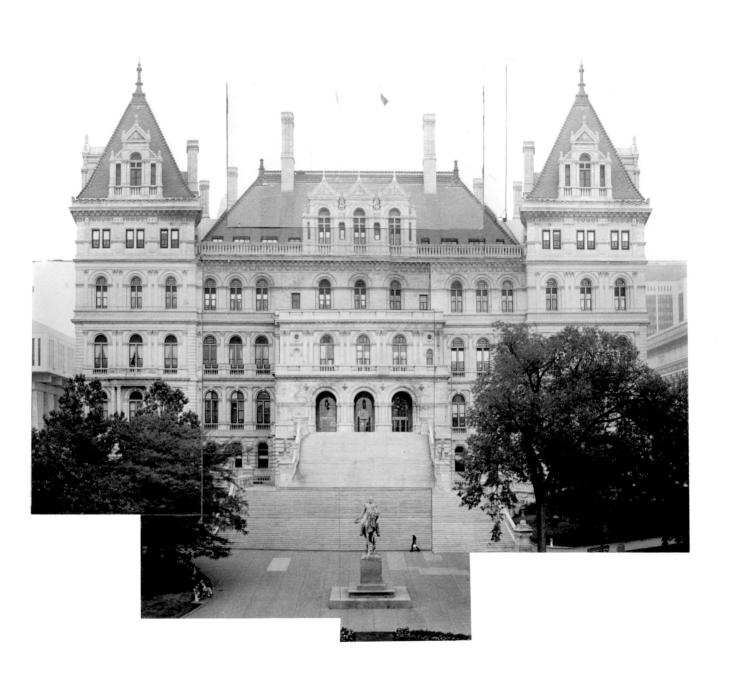

Dan Weaks *East Facade*

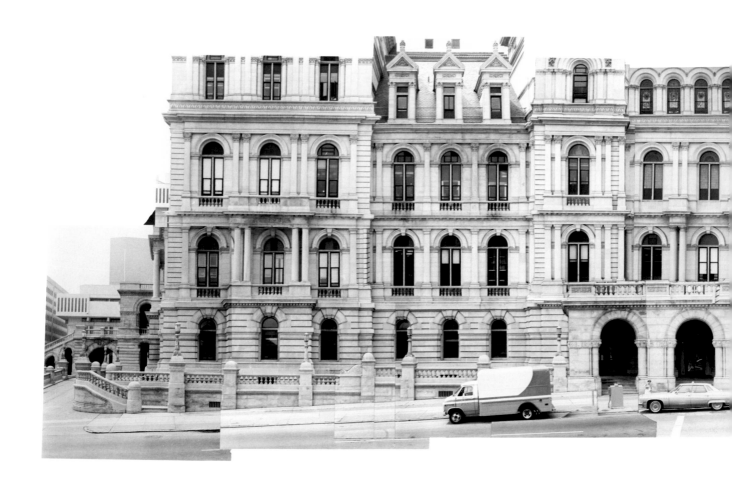

North Facade

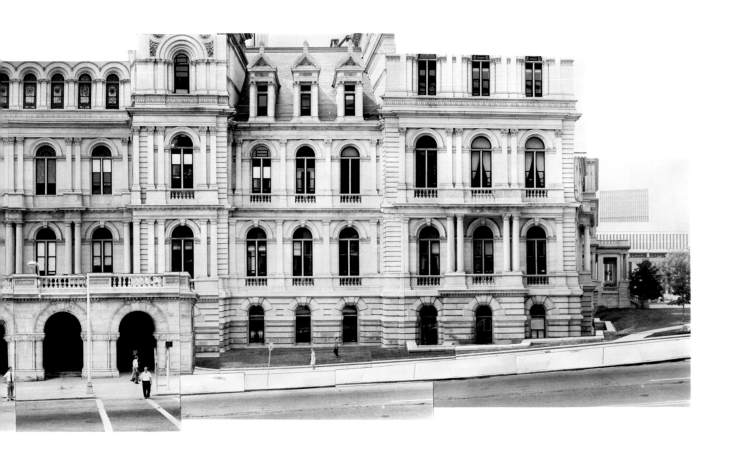

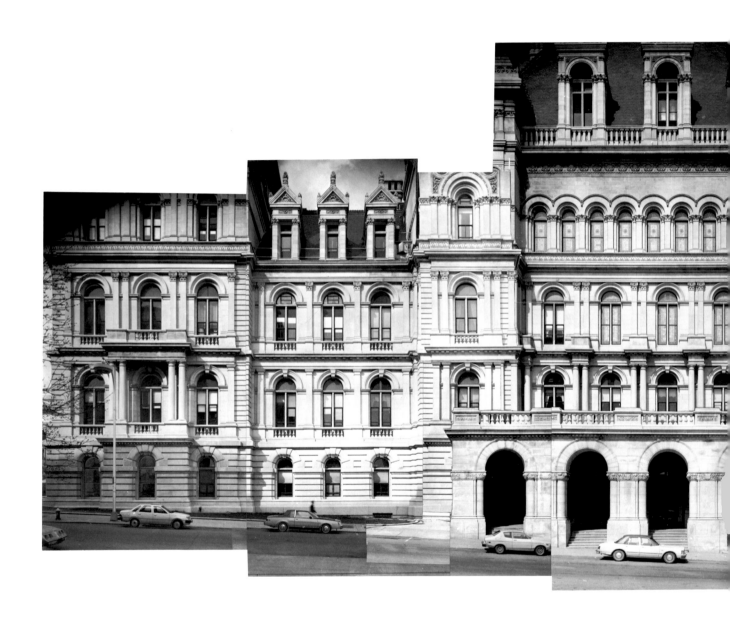

South Facade

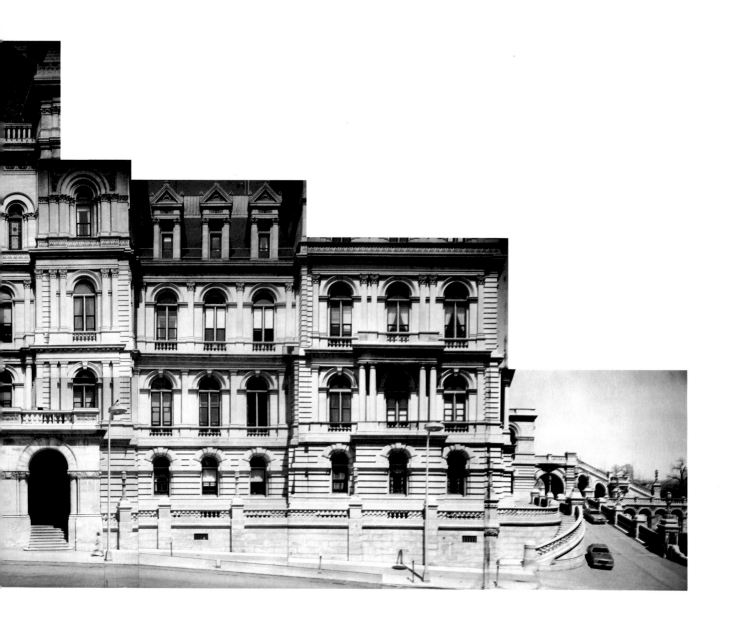

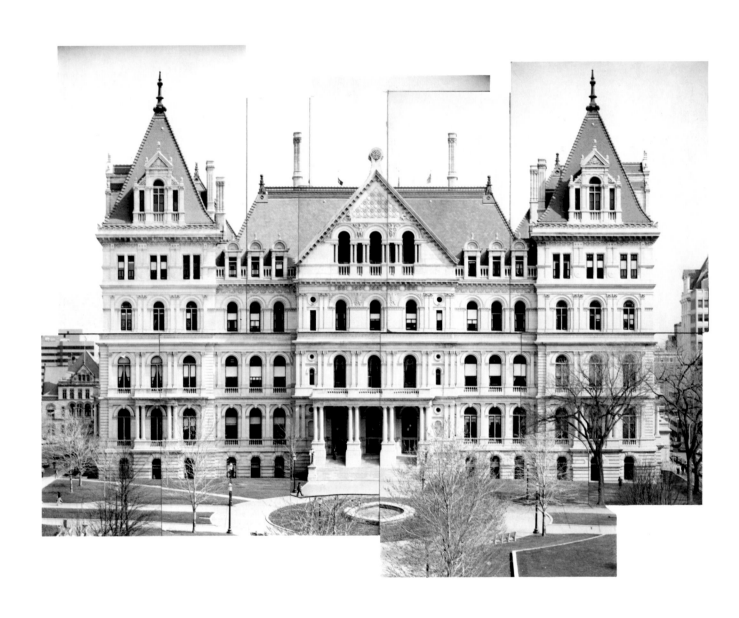

West Facade 18

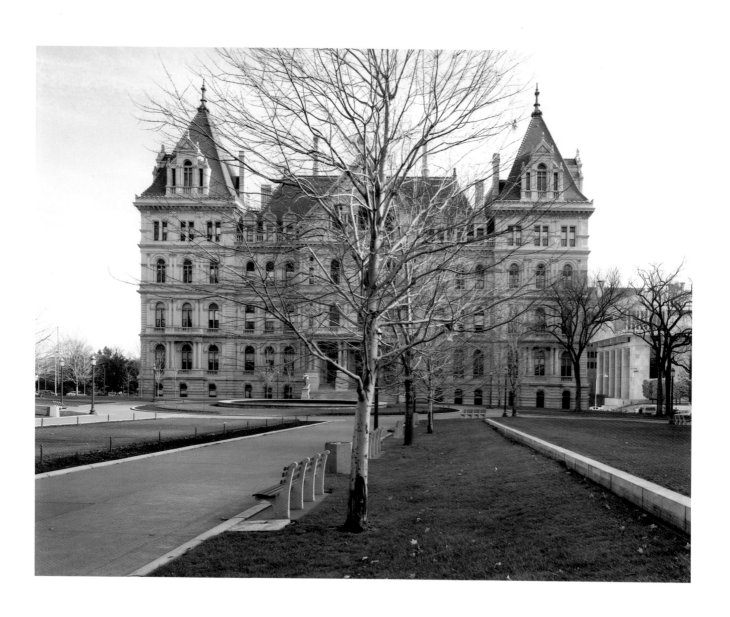

*S*TEPHEN *S*HORE *West Capitol Park and West Facade*

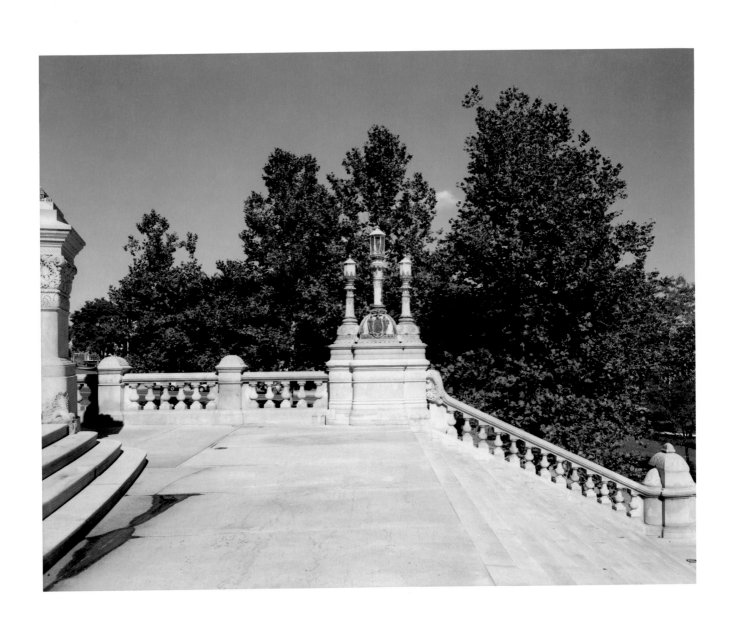

Balustrade, Pedestal, Light Fixture on the Intermediate Landing of the Eastern Approach

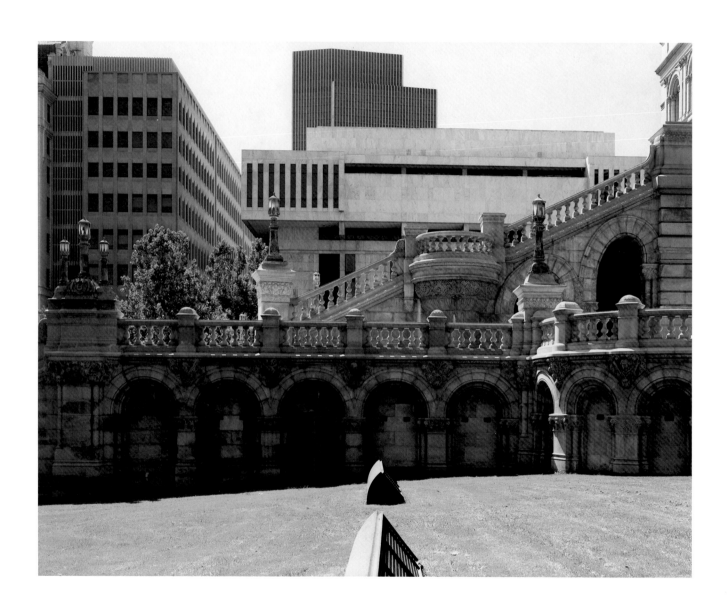

Blind Arcade and Balustrades, Eastern Approach

Carriage Way Exit, Eastern Approach

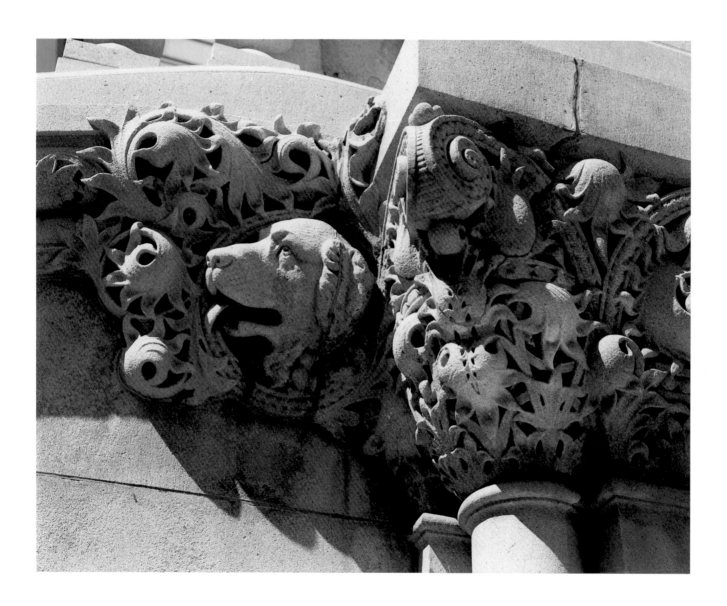

Detail, Eastern Approach

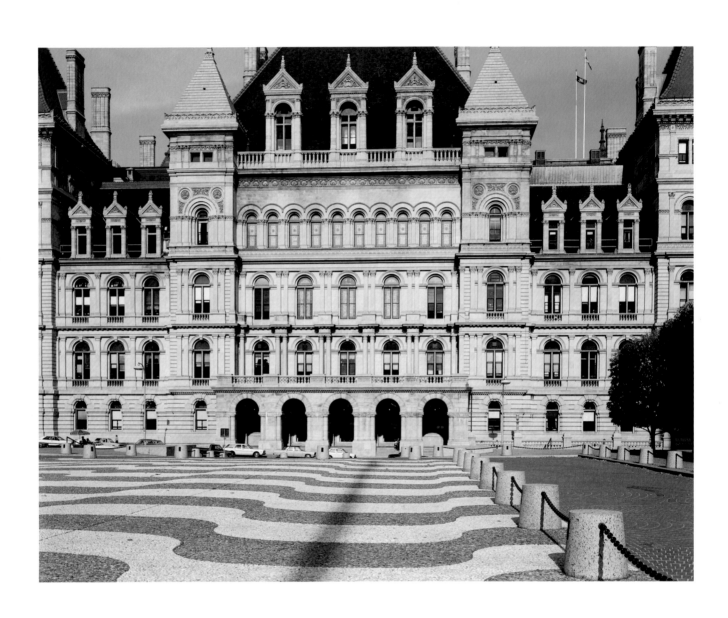

South Facade from Empire State Plaza 24

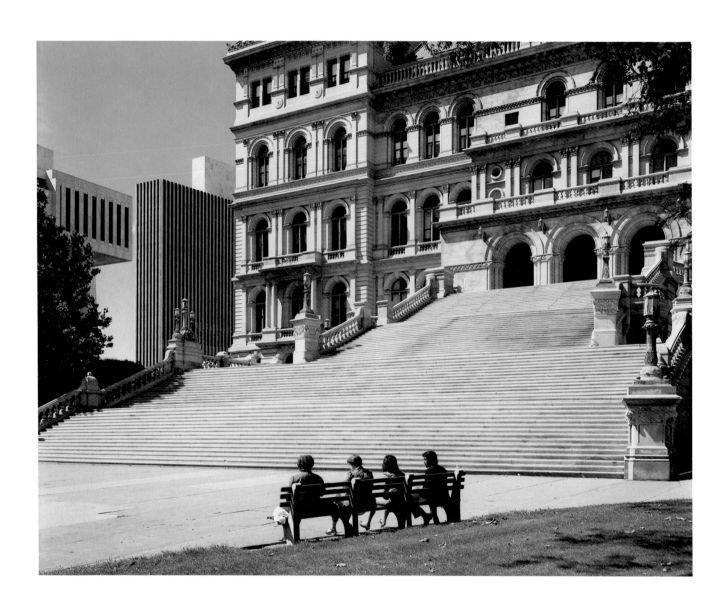

The Seventy-Seven Steps of the Eastern Approach

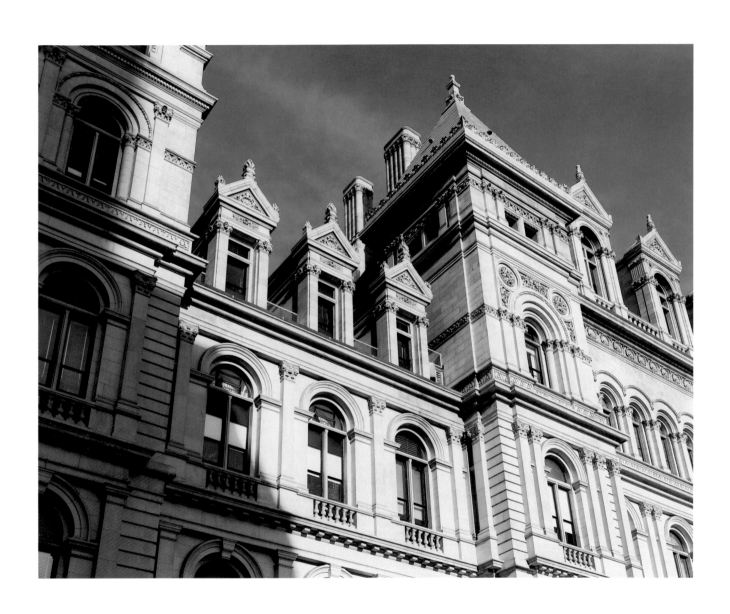

Portion of the South Facade

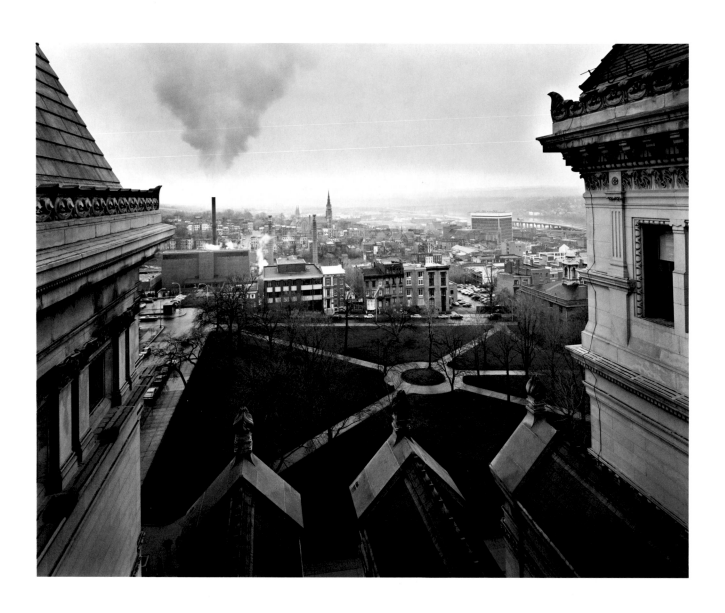

WILLIAM CLIFT *Looking North from the Roof of the Capitol*

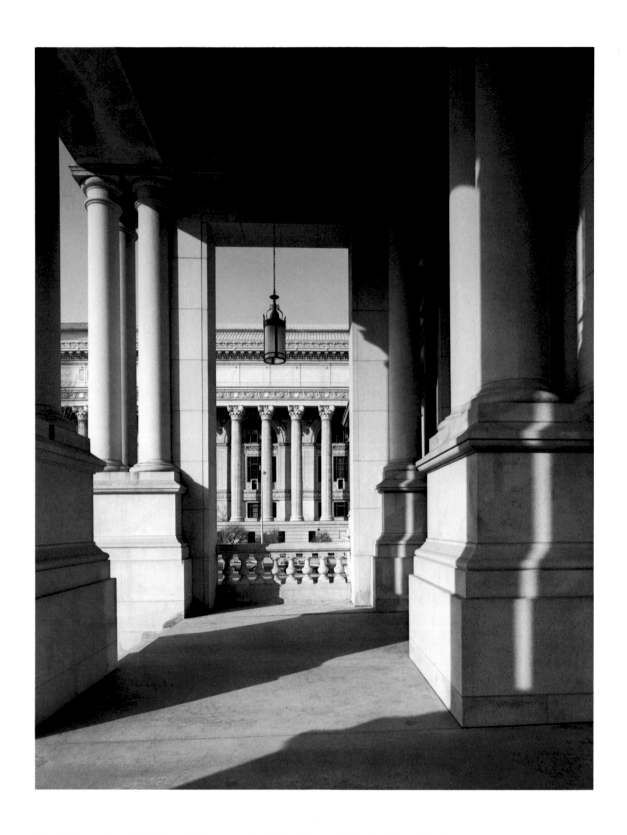

The Colonnade of the State Education Building Framed by the West Portico 28

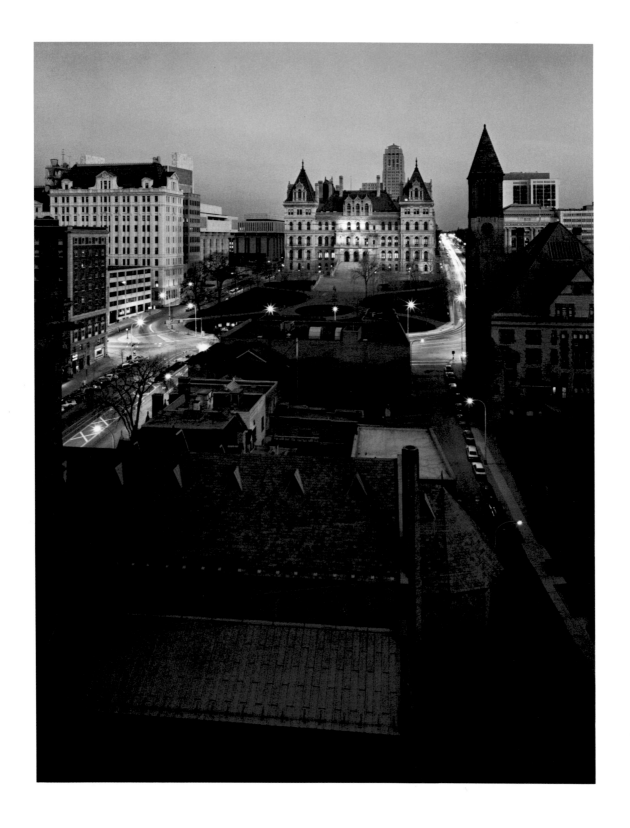

The Capitol from the East

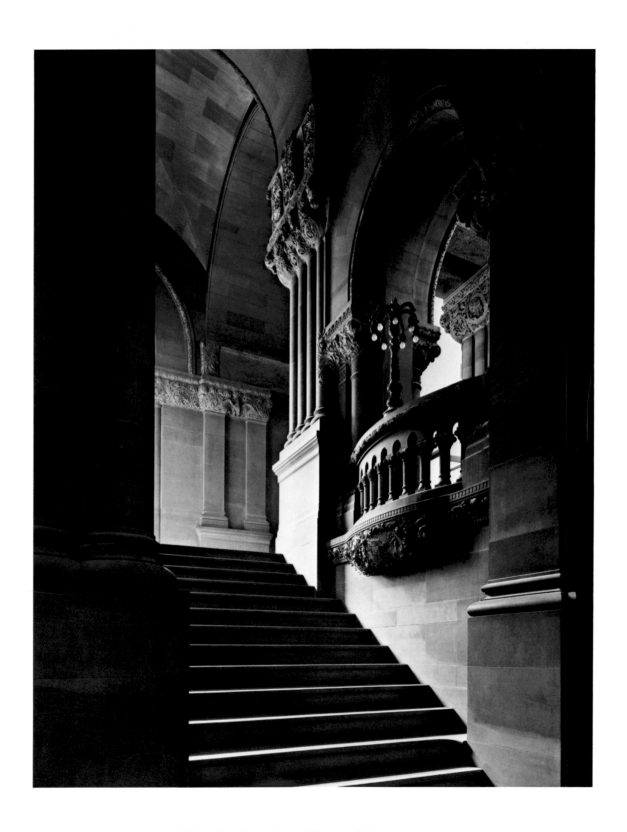

Looking Toward the Third-Floor Landing, Great Western Staircase 30

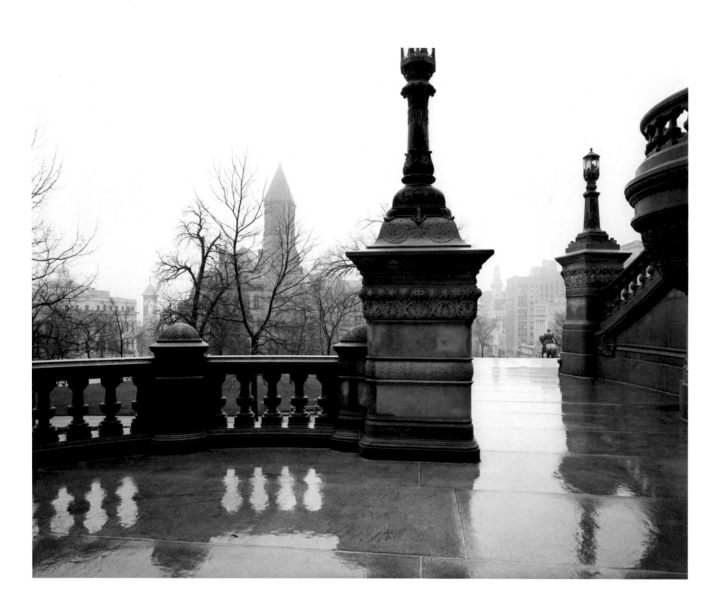

Looking East from the Intermediate Landing of the Eastern Approach

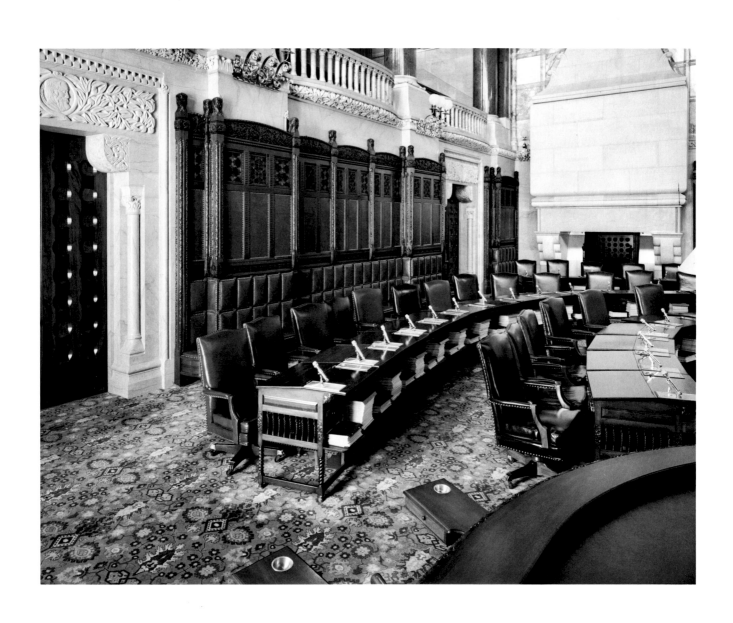

The Restored Senate Chamber, Majority Side

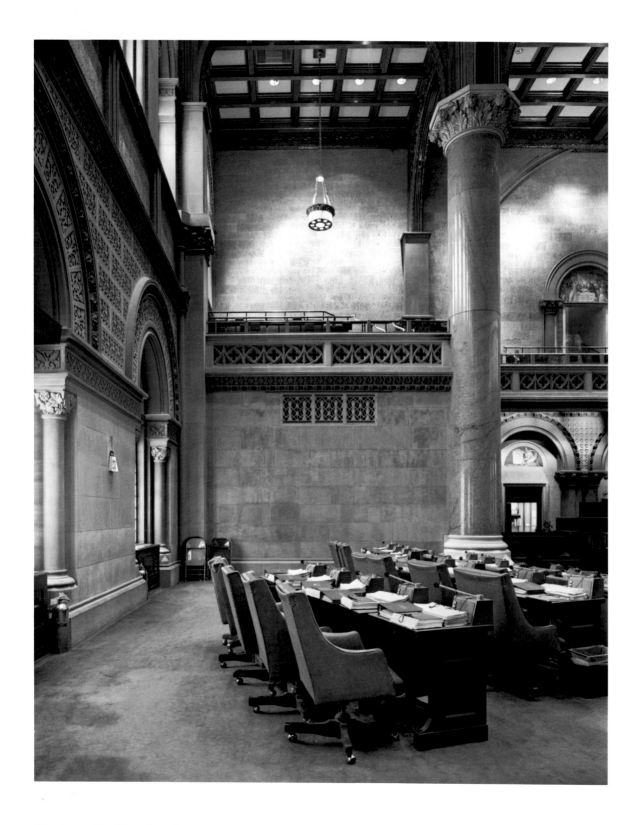

The Assembly Chamber, Minority Side

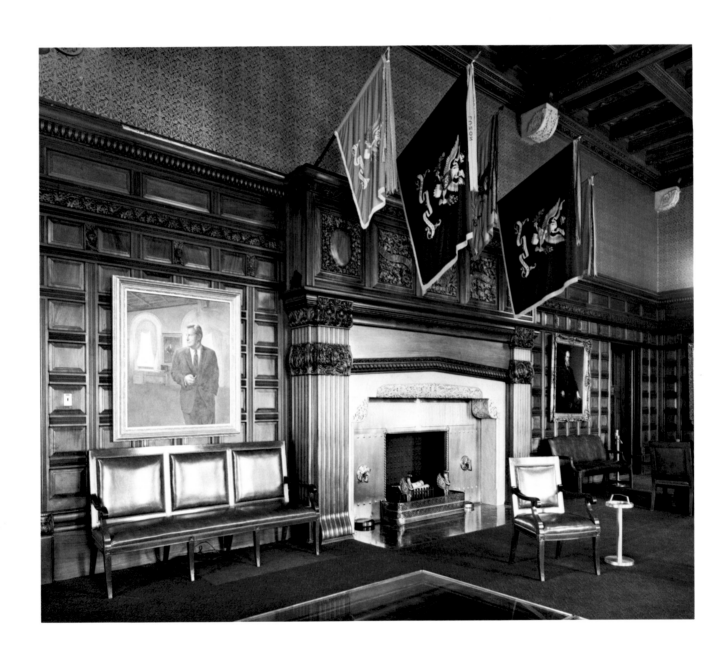

The Executive Chamber as It Appeared in 1984 before Restoration

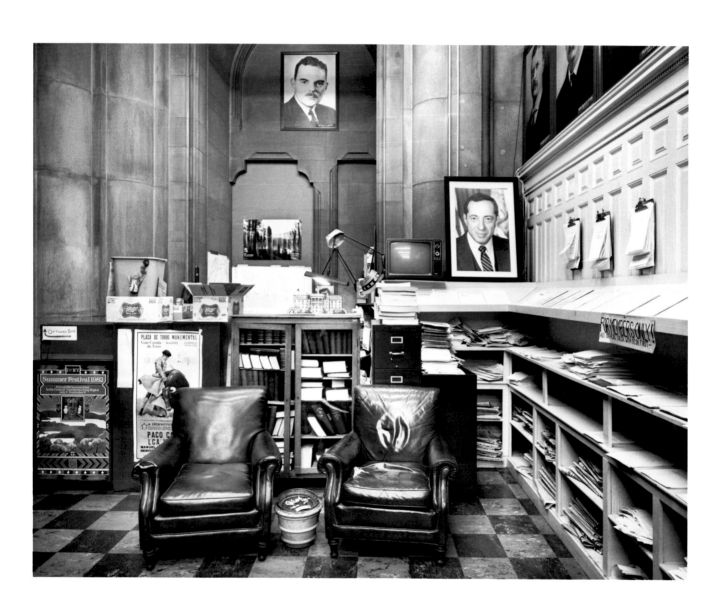

The Offices of the Legislative Correspondents Association

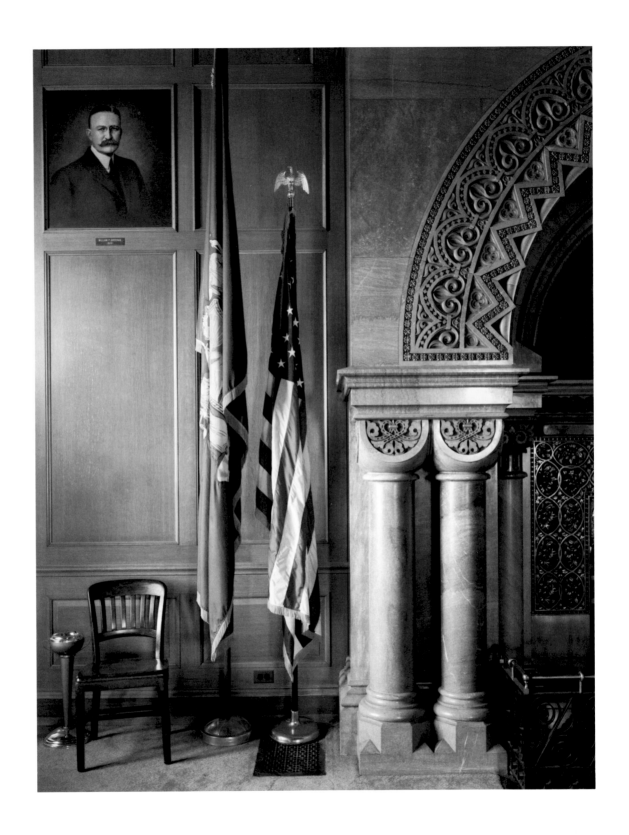

Detail, the Assembly Parlor

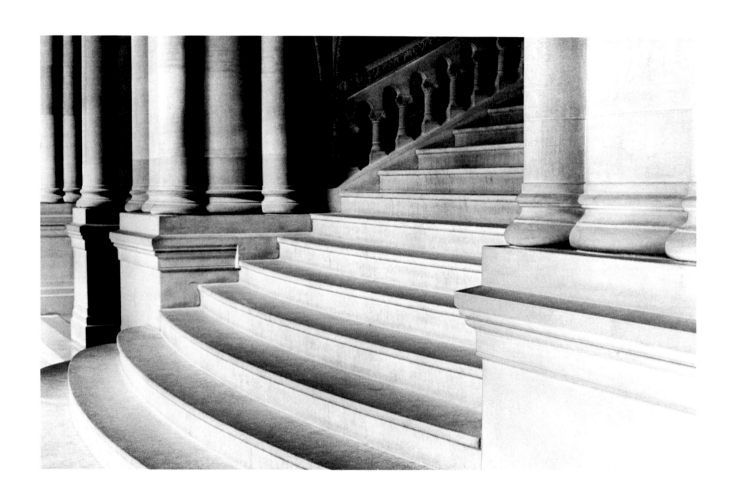

JUDITH TURNER *Steps at the Landing, Third Floor of the Great Western Staircase*

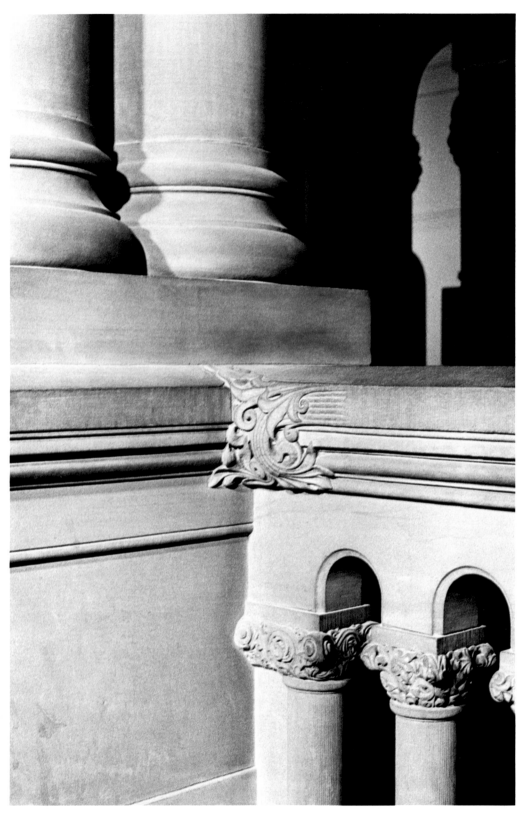

Balustrade, Pedestal, and Column, Fourth Floor of the Great Western Staircase 38

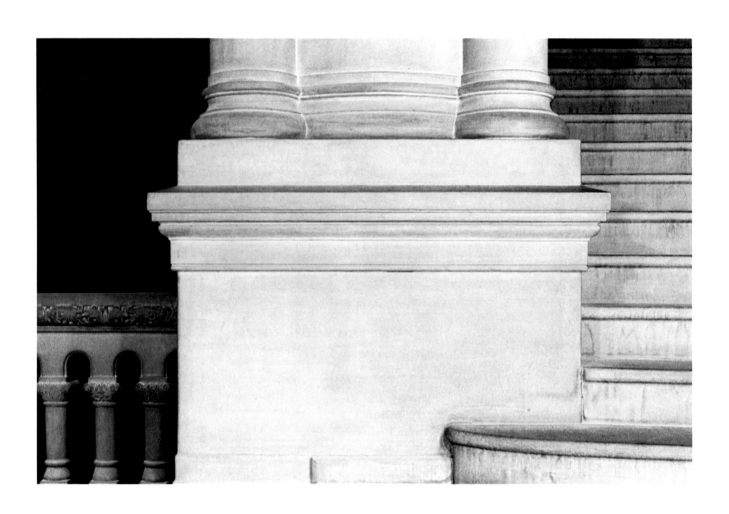

Pedestal, Balustrade, and Steps, Third Floor of the Great Western Staircase

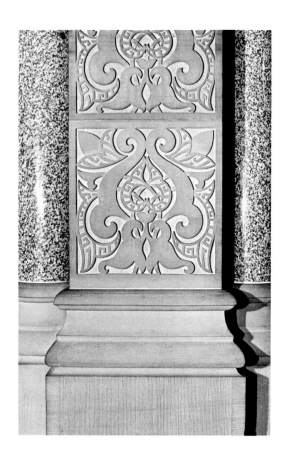 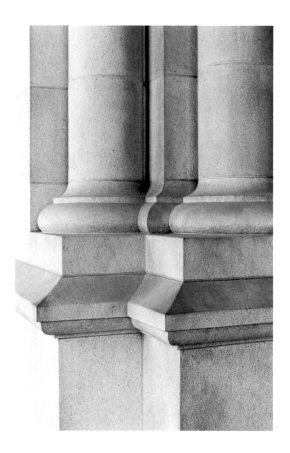

Pier and Attached Columns, First Floor of the Senate Staircase

Pedestal and Attached Columns, Porch of the Eastern Approach

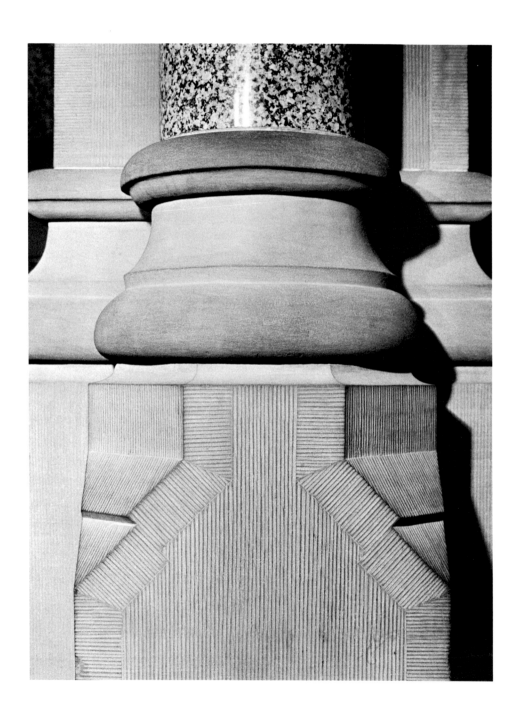

Pier and Attached Column, First Floor of the Senate Staircase

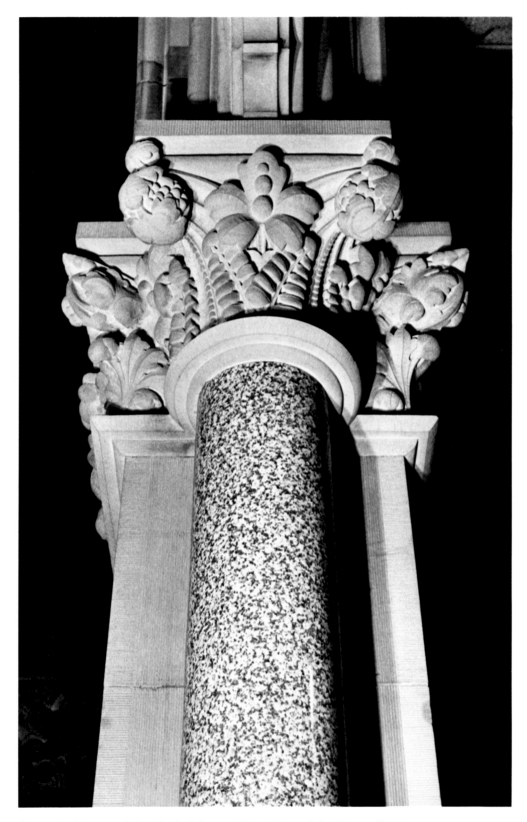

Capital of Pier and Attached Column, First Floor of the Senate Staircase

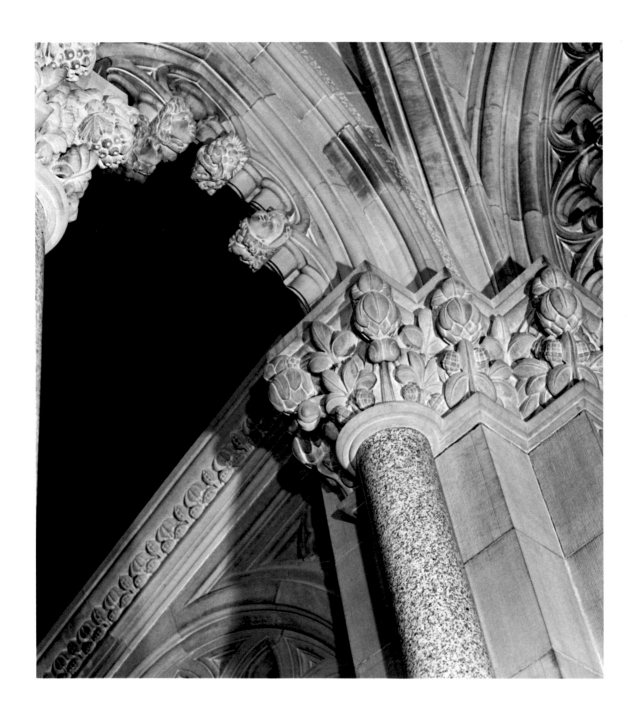

Crocket Arch, Third Floor of the Senate Staircase

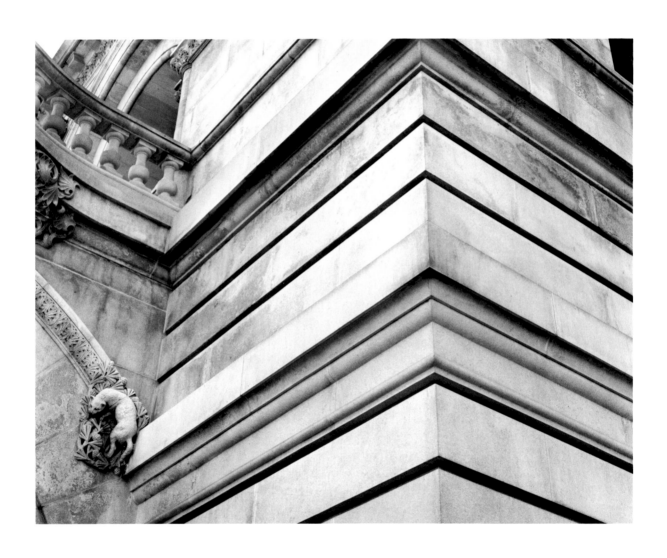

Base of Porch, North Side of the Eastern Approach 44

AFTERWORD

RESPONSIBLE ARCHITECTURAL RESTORATION is built on knowledge that is largely gained from photographs. Written accounts of a building can provide description, history, and criticism; architectural records can supply technical information; painting, drawings, and prints illustrate and often idealize, but the photograph is especially prized for its veracity.

In the last few years, the Temporary State Commission on the Restoration of the Capitol has identified several hundred historical photographic images of the Capitol. Stereopticon views, press photographs, and tourist snapshots alike have all provided critical information. From these documents, carpets and chandeliers have been faithfully replicated, past events have been more accurately pieced together, and the needs of the people, both those who work in the building and those who turn to it as the symbolic focus for New York State government, are better understood.

The Capitol Commission has also turned to contemporary photography to record the present condition of the building, good and bad. The idea for this book and exhibition of photographs arose out of a simple need: to increase the Capitol Commission's stock of documentary photographs. A search for a photographer to meet this need evolved into the commissioning of four photographers of note, each providing us with a singular and incisive interpretation of the same subject. This evolution was catalyzed by the Director of the International Center of Photography, Cornell Capa, who very wisely pointed out that if you just commission "some lousy pictures" it would not only be boring, it would be a waste of money.

In hindsight, the choice of using four artists so varied, both philosophically and stylistically, seems appropriate to the subject. The very architectural history of the building reads like a debate on nineteenth century approaches to capitol design. In a sense, the Capitol stands as a monument to the various styles of its creators: Fuller, Eidlitz, Richardson, Perry. The Neo-Renaissance, the Gothic, and the Romanesque traditions were here melded together and set in stone. What single architectural style could have been more appropriate for a capitol, judgment seat for the interpretation of the laws of the state?

As befits the inherent eclecticism of the subject, and of our post-modernist moment as well, the photographs presented here are richly varied. The differences in the works of each of these artists, William Clift, Stephen Shore, Judith Turner, and Dan Weaks, are obvious enough. Clift and Shore, who have done most of their work independent of commissions, both worked on the project *Courthouse*, a photo-documentary of American courthouses initiated and funded by the Seagram's Corporation in 1976. Clift's architectural photographs, then as now, are faithful to the particular history of a building and to the particular ambitions and peculiarities of its architects. Shore's views show us how the building is: what its contemporary function is, what it looks like in its present context, and how that context changes with the seasons and with fluctuations in the quality of light.

Judith Turner has won the admiration of many contemporary architects for her ability to trap what Michael Graves has termed the "fragments" of a building, those elements composing a space that define its essential character. For Weaks, a commercial photographer, the challenge of photographing the Capitol was like that of the NASA cameras mapping the moon: to show the building exactly as it is, and yet how we never see it, without subjective input. Previously, Weaks undertook the ambitious task of photographing every building in Manhattan, splicing together entire streets to be viewed as a whole. In a scientific experiment, Weaks's work would have been termed the "control" or the bare-bones truth to which the other variables could be compared.

It is our intention that these photographs raise questions about varying approaches to architectural photography. In the larger scheme, the real issue, the Capitol, will begin to take on a new dimension, as seen through the eyes of these very careful observers.

The realization of this project owes much to Anna Winand, Emily Braun, Julie Saul, Howard Reed III, and Barnabas McHenry. We would like to thank the members of the Capitol Commission, notably Matthew Bender IV, Norman Rice, Lewis Swyer, and former commissioner, David Dzunczyk, for their tireless support and assistance. John Egan, Commissioner, and Albert Brevetti, Capitol Architect, of the New York State Office of General Services provided invaluable help for which we are most grateful.

PARI STAVE CHOATE
DENNIS MCFADDEN
ANNE UMLAND

THIS PUBLICATION IS MADE POSSIBLE,
IN PART, BY THE GENEROUS SUPPORT OF
THE LILA ACHESON WALLACE FUND
AND THE EQUITABLE REAL ESTATE GROUP.

Typeset by Crane Typesetting Service, Inc., Barnstable,
Massachusetts. Printed by the Meriden-Stinehour Press,
Meriden, Connecticut. Library of Congress Catalog
Card Number: 85-072491. ISBN: 0-89381-209-9.
Book design by Wendy Byrne

The Staff at Aperture for *The Capitol in Albany*: Michael
Hoffman, Executive Director; Christopher Hudson, Vice
President, Publishing; Lawrence E. Frascella, Managing
Editor; Katherine Houck, Production Manager; Andrew Semel
and Eileen Smith, Editorial Assistants.

Aperture Foundation, Inc., publishes a periodical, books,
and portfolios of fine photography to communicate with
serious photographers everywhere.
A complete catalog is available on request.
Address: 20 East 23 Street, New York, New York 10010.